MW00950310

Full Circle

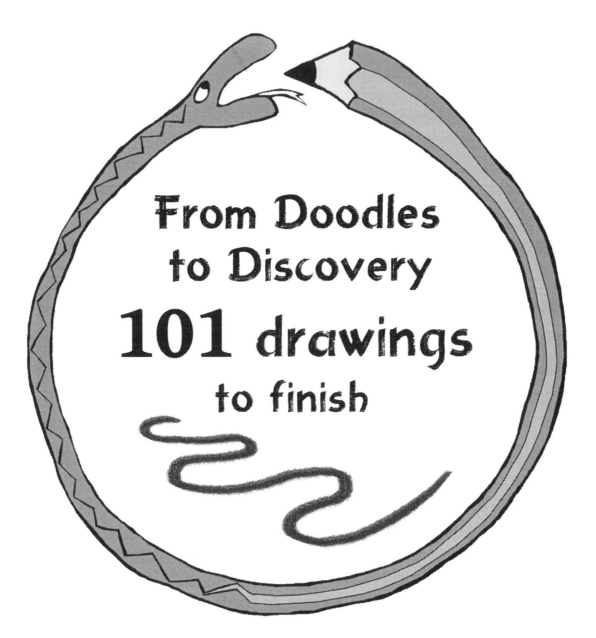

From Doodles to Discovery

101 drawings to finish

From Doodles to Discovery Series Vol I

Katja Vartiainen

'Full Circle"
II edition, 2016
First published in 2015
Katja Vartiainen
ISBN--13: 978-1517097929
www.artist-katja-vartiainen.de

No part of this book may be reproduced by any mechanical, photographic or electronic process, nor it may be stored in a retrieval system, transmitted, translated into another language, or otherwise copied for public or private use without the permission of the author.

From young to old, alone or together, here is 101 doodles to discover. Continue them with what ever comes to your mind! You can even color them when you are done. Hint: if you want more challenge, turn the doodle sideways or upside down! Remember, there is no one way to finish these doodles. Enjoy!

Pour les jeunes et les vieux, seul ou avec quelqu'un, ici 101 dessins pour découvrir. Continuez-les avec tout ce qui vous passe par la tête. Vous pouvez les colorier après avoir fini les dessiner. Petit conseil: si vous voulez un défi, tournez le dessin sur le côté ou renversez-le! Rappelez-vous qu'il n'existe pas uniquement une façon de finir ces doodles. Amusez-vous bien!

Nuorille ja vanhoille, yksin tai yhdessä, tässä 101 luonnosta löydettäväksi. Piirrä kuvat valmiiksi miten mieleesi saattaa juolahtaa. Voit värittää ne kun olet valmis. Vihje: kun haluat enemmän haastetta, käännä kuva sivuittain tai jopa ylösalaisin. Muista ettei ole yhtä oikeaa tapaa piirtää kuva valmiiksi! Iloista piirtämistä!

Ob jung oder alt, oder alle zusammen: Hier sind 101 Bilder, die es zu entdecken gibt. Vervollständige die Skizzen, mit was auch immer deine Kreativität beflügelt. Ein kleiner Tipp: Drehe die Entwürfe auch mal seitlich oder verkehrt herum, und bemale die fertigen Skizzen mit Farbe. Denk daran: Es gibt unzählige Möglichkeiten, denn deiner Phantasie sind keine Grenzen gesetzt. Viel Spass!

De joven a viejo, solo o en conjunto, aquí hay 101 bosquejos por descubrir. Continúa con lo que viene a tu mente! Incluso puedes colorearlos cuando hayas terminado. Sugerencia: si quieres más reto, gira el bosquejo de lado o boca abajo! Recuerda, no hay una sola manera det erminar estos bosque jos. Disfruta!

Från unga till gamla, ensam eller tillsammans, här är 101 skissar att upptäcka. Fortsätt dem med vad kommer till ditt sinne! Du kan även färga dem när du är klar. Tips: Om du vill ha mer utmaning, vrid skissen sidled eller upp och ner! Kom ihåg, det finns inte bara ett sätt att avsluta dessa skissar. Mycket nöje!

Thank you Jasmin, Liisa, Sini & Christian!

Recommended tools:

a pencil

colored pencils

a ballpoint pen

an ink pen, if it does not make puddles

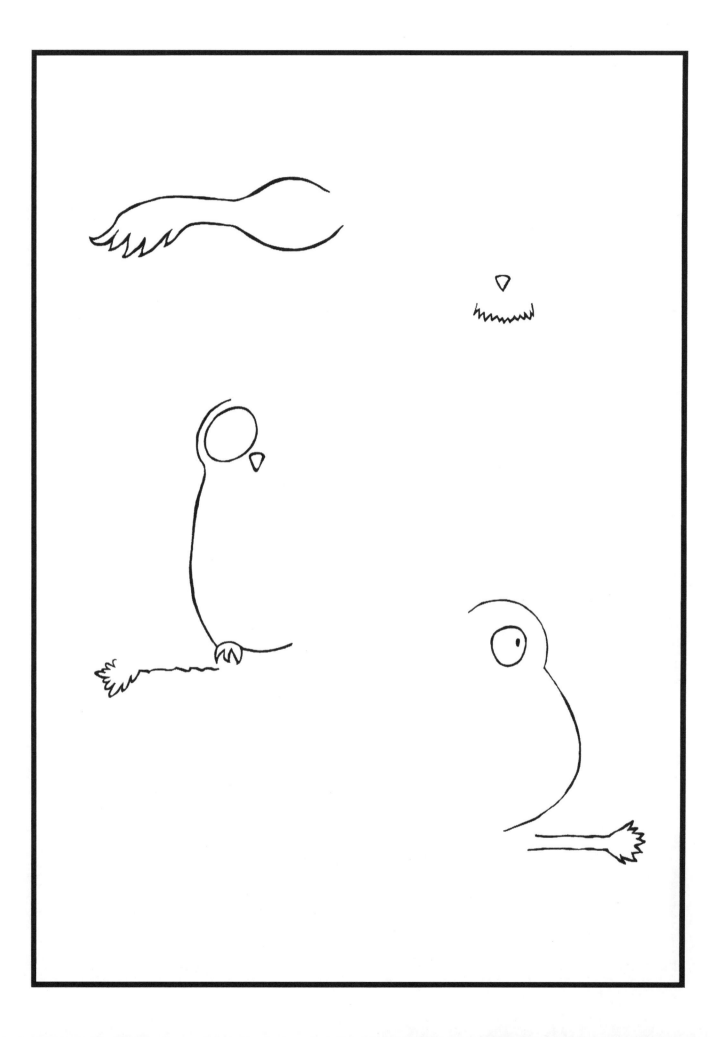

Katja Vartiainen has an art background. She is a painter, an illustrator, and recently a storyteller. Her visual inspiration comes from fine arts as well as from the wide cornucopia of comics and graphic novels. Her literary interests are wide and varied.

With her husband they share a taste for humor, multi-dilettantism, and they get inspired by our tragicomic planet and its curious creatures.

She is currently working on a graphic novel: 'Elves and the Agro Adventure' (coming in 2016) and with her husband they have published a picture book: 'Kitchenelves Revolution'(on Amazon).

Work:

'Total Square, 101 Drawings to finish, Vol II from Doodles to Discovery- series' (Amazon) 2016
'Kitchenelves Revolution' (Amazon) 2015
'Full Circle, 101 Drawings to finish, Vol I from Doodles to Discovery- series' (Amazon) 2015

www.artist-katja-vartiainen.de
twitter: @KatjaVartiain1
You can also find her author pages on Goodreads.com and Amazon.com: Katja Vartiainen

85188879R00061

Made in the USA
Lexington, KY
29 March 2018